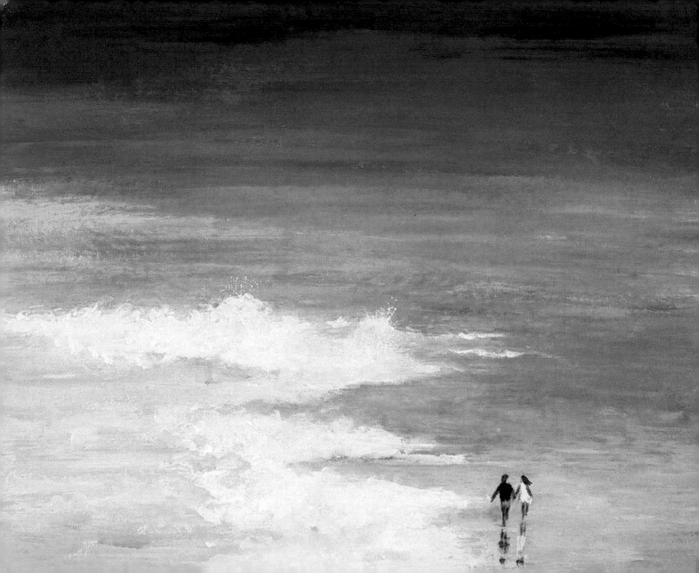

An Imprint of HarperCollinsPublishers

First published in 2007 by Collins, an imprint of HarperCollinsPublishers 77-85 Fulham Palace Road Hammersmith, London W6 8JB, UK

www.collins.co.uk

Collins is a registered trademark of HarperCollins Publishers Limited.

© Soraya French 2007

All rights reserved. No part of this publication may be reproduced, stored in a retrieval system, or transmitted, in any form or by any means, electronic, mechanical, photocopying, recording, or otherwise, without the prior written permission of the publishers.

FIRST U.S EDITION published in May 2008.

HarperCollins books may be purchased for educational, business, or sales promotional use. For information in the United States, please write to: Special Markets Department, HarperCollins Publishers, 10 East 53rd St., New York, NY 10022.

www.harpercollins.com

The name of the "Smithsonian," "Smithsonian Institution," and the sunburst logo are registered trademarks of the Smithsonian Institution.

Smithsonian consultant: Stephanie Halpern

Library of Congress Cataloging-in-Publication Data

French, Soraya. Acrylics / Soraya French. -- 1st ed. p. cm. -- (30-minute art) Includes index. ISBN 978-0-06-149183-2 1. Acrylic painting--Technique. I. Title. ND1535.F74 2008 751.4'26--dc22

2007043285

Color reproduction by Colourscan, Singapore Printed and bound by Printing Express, Hong Kong

12 11 10 09 08 8 7 6 5 4 3 2 1

Dedication

To Tim, my husband and best friend, whose selfless love, help, and encouragement have enabled me to follow my dream.

Acknowledgments

My thanks to Caroline Churton, without whose patient help and guidance this book wouldn't have come to fruition; to Diana Vowles, for hours of editing and all the encouraging e-mails; to Kathryn Gammon for her fantastic design work; to Tracy Mason of Daler-Rowney, and to Sally Bulgin and Caroline Griffiths of *The Artist* magazine for believing in me. My grateful thanks to my tutor, Richard Plincke, for his influence in the way that I perceive art, and also my wonderful teacher, Geoff Crabb, who has so generously fortified me with his vast knowledge and wisdom over the years. Finally, to my two lovely children, Yasmin and Saasha, for their love and understanding, and most of all to my father-in-law, Roy French, for encouraging me to pursue my painting.

Page 2: Caribbean Sea, 12 × 14 in. (30 × 36 cm)

CONTENTS

- 6 Introduction
- 10 Essential equipment
- 16 Color and tone
- 30 Techniques
- 50 Creating textures
- 58 Quick studies
- 74 Composing your picture
- 82 The complete picture
- 94 Further information
- 96 Index

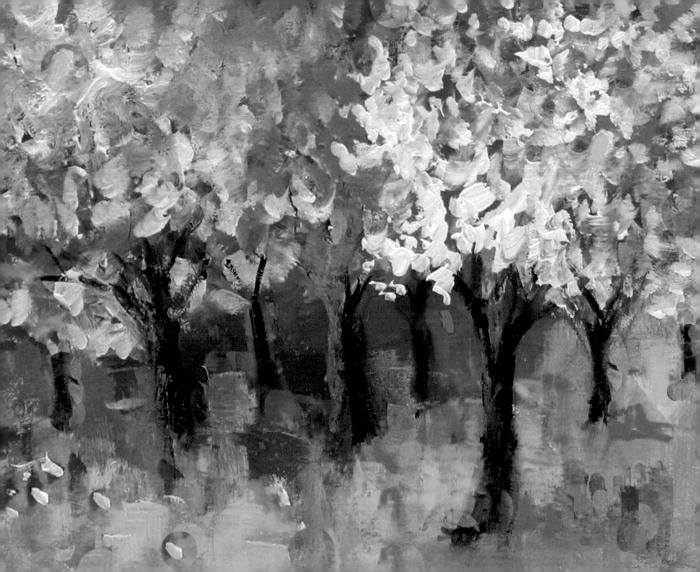

INTRODUCTION

Acrylic paint is by far the most versatile medium available for the artist today. Water-based, it can be used like watercolor but also offers opacity that makes it especially suitable for the beginner. At the same time, more experienced and experimental artists can take advantage of the unique characteristics of the medium which provides excellent color-fastness—and they can push the boundaries to express and develop their ideas.

Within the pages of this book, you will be able to find all you need to get you started on your journey of exploring this fantastic medium—and you'll discover the possibilities of what you can achieve with your paints in just 30 minutes.

Cherry Blossoms

 $(7 \times 9 \text{ in.} (18 \times 23 \text{ cm}))$ This painting is a good example of using the heavy texture and vibrancy of acrylic colors to maximum effect.

The advantages of acrylics

Acrylics are an odorless, quick-drying, flexible medium that can mimic both watercolor and oil colors. However, they also have some unique qualities of their own. The opacity of acrylic pigments enables the artist to cover or rectify mistakes, making them ideal for beginners; they can be applied with brushes or a painting knife; they can be used on a multitude of different surfaces; they dry fast, so a quick succession of washes and layers can be applied easily; and while water is perfect for diluting them, there is also a range of mediums and additives that can modify them (but the latter should be used sparingly).

Consequently, acrylics offer the artist numerous possibilities for experimenting with different techniques of application and creating exciting effects with texture. They are also one of the most durable and permanent mediums available.

> ▶ Poppies on Blue 12 × 12 in. (30 × 30 cm) In this picture, the poppies were scraped over the blue background with a painting knife.

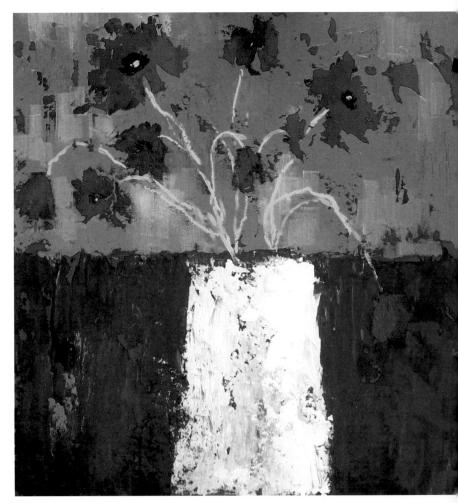

The aim of this book

Many people lead such busy lives today that the idea of a time-consuming leisure activity, however pleasurable, can be offputting. The aim of *30 minute Acrylics* is to give you concise information and quick exercises so that you can begin painting without having to invest a huge amount of time. Acrylics are the ideal medium, because it requires only a little preparation and you can be as spontaneous as you want.

I hope that after trying a few of the exercises you will share my enthusiasm for this amazing medium—and you may even realize that this is the start of a lifelong pursuit.

Mediterranean Buildings

(detail) A combination of collage, ink, and heavy body color provided the texture for this painting.

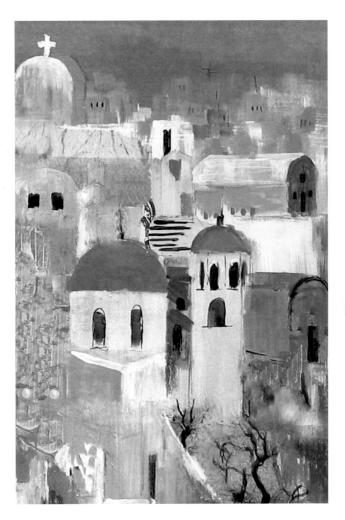

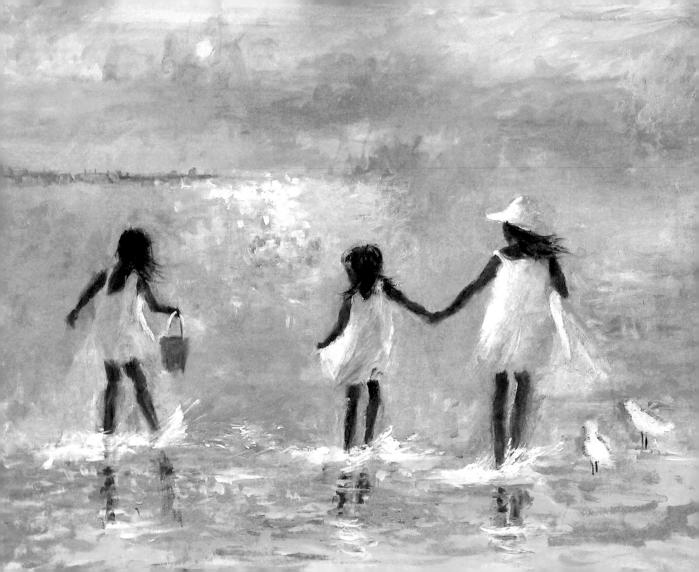

ESSENTIAL EQUIPMENT

The wide range of art materials available to the artist today can sometimes be more of a hindrance than a help. The variety of consistencies in acrylic color can make the choice confusing for the beginner, but the exercises in this book will help you to make the right choice for a particular subject or technique. In this chapter, you will find details of all the basic equipment you need to get started—paints, brushes, supports, and accessories.

While they are more expensive, I cannot emphasize too highly the importance of investing in good-quality artist's materials, which go a long way to ensure your progress and enjoyment of painting.

Children on the Beach

16 × 20 in. (40 × 51 cm) Here I used both transparent and opaque colors, with Titanium White for the light areas.

Acrylic colors

Acrylic colors come in different consistencies, and the ones you select will depend upon your individual style and subject matter. The various types can be intermixed, giving you an additional range of choice. Within the categories below, the consistency varies from manufacturer to manufacturer, as do the colors, even if the name is the same.

Soft body

Otherwise known as flow formula, this paint is heavier than acrylic ink but has a runny consistency and is more suitable for the watercolorist. It can be thickened by using impasto gel. An example is Daler-Rowney System 3 colors, available in tubes and larger containers.

wacho

Heavy body

These colors, produced by Golden and Liquitex, are more full-bodied and can be thinned to use in watercolor style or applied thick like oil paints. However, you will need to thicken them further for heavily textured styles.

Super heavy body

Formulated to create heavy textures and to retain brushstrokes, these acrylics have a more buttery consistency; however, they can still be thinned down if you need to glaze with them. The Daler-Rowney System 3D range comes in large tubes.

> Soft body, heavy body, and super heavy body acrylic paints give the artist varying consistencies to work with.

Inks

Acrylic inks are the most fluid form of acrylic colors. They are highly suitable for watercolor techniques but have the advantage of drying to a waterproof film that cannot be disturbed once dry, with the consequence that there is less likelihood of muddy colors.

The inks are wonderfully vibrant and highly permanent. They can be used on their own or combined with thick color, and they can also be applied as glaze over thick color at the latter stages of a painting. They come in small bottles with a useful dropper.

Available in both brilliant and subtle colors, acrylic inks are invaluable for their versatility and permanence.

Mediums and additives

ACRYLIC AR

While you can dilute acrylics with water, matte and gloss mediums can be added freely in place of water to the paint mix to aid better flow of color and to increase transparency. Both mediums are very useful in the glazing technique of painting in acrylics where the paint is applied in layers. In this case, water is only used to clean the brush and the medium is used in place of water with a damp brush.

Texture paste or gel can be added to the support prior to painting and shaped into the desired effect, let dry, and be over painted. Alternatively, it can be added to the paint mixture to add bulk. This is useful for painting in impasto style and using a painting knife.

Additives, such as slow-drying medium or retarder, lengthen drying time to aid casier blending of one color or tone into another. The additives change the nature of the paint and should be used strictly according to the instructions on the bottle.

QUICK TIP

Have a separate watercolor-type palette for the inks and keep a well for each color—remaining stains may affect new colors.

Brushes

Invest in a set of good-quality synthetic watercolor and acrylic brushes, the former to use with the inks and the latter, which have stiffer hair, for the opaque techniques. The size of your brushes depends on the size of your paintings, but a 1-inch (25-mm) onestroke wash brush, a short flat No. 12 acrylic brush for covering larger areas, and a selection of smaller round brushes and flat brushes will suit most artists. Riggers in both the watercolor and acrylic range will also be useful.

Palettes

When acrylic paints dry they form a plastic film, so it is important to keep them wet during a painting session. A special acrylics palette comprises a tray, either two layers of paper (absorbent and tissue) or an absorbent sponge and special paper, and a lid. The layers are dampened to make a surface to mix paints on. You can also spray the paints from time to time to keep them workable during a painting session. With a damp surface to mix colors on and a lid to keep the moisture in, a special acrylics palette helps to keep the paints workable for a longer period.

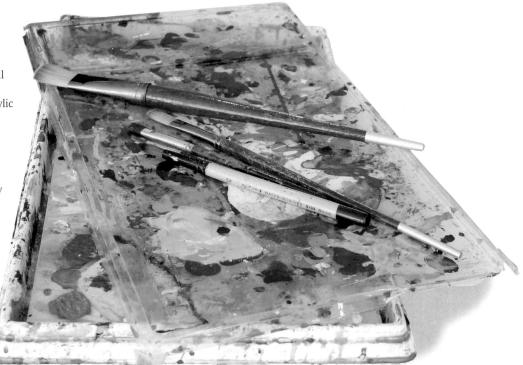

Supports

Acrylics are so versatile it is easier to say which surfaces you cannot paint on instead of list those on which you can. Oil-based and shiny surfaces are unsuitable because the color will peel off at a later stage. However, you can use all types of watercolor paper, acrylic paper, bristol board, and many types of canvases.

Gesso

Acrylic gesso is a primer that is used to prepare the surface prior to painting. This is optional when you use watercolor paper, acrylic paper, or bristol board, but it should be used on Masonite, particleboard, or MDF (medium-density fiberboard). Gesso is available in both white and black.

Other equipment

You will also need a comfortable easel or table easel, a painting board, water jars, masking tape, and paper towels. A painting knife is also useful.

> Supports you can use acrylic colors on include canvas, acrylic paper, bristol board, and watercolor paper.

watercolor paper

canvas

acrylic paper

bristol board

watercolor paper

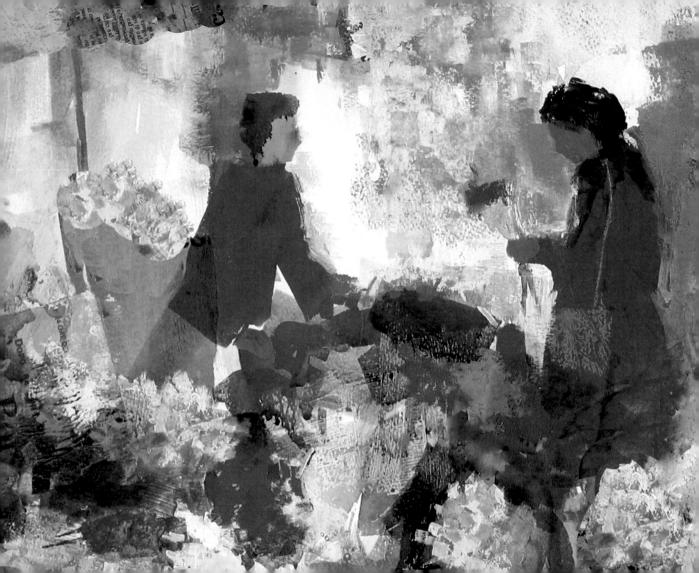

COLOR AND TONE

Color is the most exciting aspect of painting and the very first element that will evoke an emotional response from the viewer. It is absolutely crucial for the beginner to invest some time in grasping a basic understanding of color and its three components: hue, saturation, and value.

Hue refers to the name of the color, such as red, blue, and yellow, while saturation is the brightness or dullness of the color and value is its lightness or darkness. This chapter explores all these aspects and gives you exercises that will help you learn how to mix and use your colors quickly and confidently.

Flower Stall

 11×15 in. $(28 \times 38$ cm) This picture is about color balance and harmony. Neutral tones create the structure and bright colors add zest.

A basic palette

Successful color mixing in acrylics can be achieved with a relatively limited number of colors, and these can be mixed to create an infinite number of secondary and tertiary colors, tints, and neutrals.

My suggested basic color palette is: Titanium White, Yellow Ochre, Burnt Sienna, Ultramarine, Lemon Yellow, Crimson Alizarin (Hue). Phthalo Blue. Cadmium Yellow, and Cadmium Red

Titanium White is a very important color in acrylic painting. As you progress you may want to add some extra colors to your palette, such as Magenta for flowers. Ceruleum (or Coeruleum) for skies Dioxazine Purple for a lovely dark purple (useful for creating dark undertones), and Payne's Gray, a versatile dark color.

As you gain experience you will create vour own voice and unique color palette, and your work will become recognizable through this.

Ceruleum

Dioxazine Purple

Payne's Grav

Titanium White

Ultramarine

Phthalo Blue

Yellow Ochre

Lemon Yellow

Cadmium Yellow

Cadmium Red

Burnt Sienna

Crimson Alizarin (Hue)

Use Payne's Gray in moderation. It is made of two or three colors and should not be mixed with more than one other color. Mixed with Lemon Yellow, it makes a useful green.

Primary colors

The three colors of red, yellow, and blue on the color wheel are known as the primary colors. These cannot be created by mixing other colors, but they do have variations within them, such as a purplered or an orange-red.

Secondary colors

Secondary colors are made by mixing the two adjacent primary colors on the color wheel. Red and blue make purple; red and yellow make orange; and yellow and blue make green.

To mix vibrant purple, orange, and green, mix the two primaries biased toward the same color. For example, the purple-biased Ultramarine blue with purple-biased Crimson Alizarin (Hue) make vibrant purple, whereas Phthalo Blue (Green Shade) and Cadmium Red, which has an orange bias, make a grayish purple.

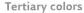

Mixing a primary and a secondary color will produce what is known as a tertiary color. For example, yellow added to orange makes a yellow-orange.

Complementary colors

Complementary colors are contrasting colors situated opposite each other on a typical color wheel, such as red and green, blue and orange, and yellow and purple. They play an important role in painting. Placed next to each other, they make dazzling and vibrant contrasts. They can also be used to modify or knock back one another—for example, a bright yellow can be dulled by adding a touch of purple.

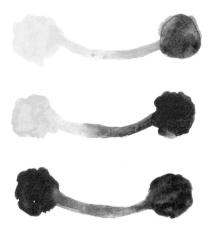

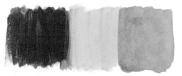

▲ Orange and yellow mixed together make yellow-orange, which is a tertiary color.

Clementine on Blue Cloth

In this example of complementary colors, the orange placed against the blue creates a lovely contrast.

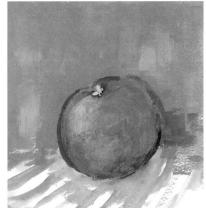

 Red, blue, and yellow are the primary colors.

Yellow and blue

Ş

mixed together make green, a secondary color. Yellow and red make orange, and red and blue make purple.

Neutrals and tints

Neutral tones and tints are just as important as the more vibrant colors. In a painting of predominantly vivid colors, the neutrals have the supporting roles; without them the painting may look too bright and garish.

Mixing neutrals

Neutrals are the hues that are not on the color wheel, such as black and white, gray, brown, and beige. Neutral grays are made by mixing complementary colors in different proportions. By varying the proportion of the individual colors used in the mix, you can create cooler or warmer versions of neutral colors. Grays mixed in this way are much more exciting than those made by mixing black and white. Browns, which are also referred to as earth colors, are made by mixing the three primaries together.

Remember that colors exist in relation to each other. A color that looks dull and muted next to a vivid color may suddenly look bright when placed next to an even more muted color, so what you mixed on your palette may look different once you have placed it in context in your painting.

Making tints

Bright acrylic colors can be made into beautiful subtle tones by adding white. These paler and more delicate shades are known as tints, and mixing primary, secondary, and tertiary colors with varying degrees of white will give you an infinite number of them.

QUICK TIP

Mixing your neutrals by using the colors that already appear in your painting makes a more harmonious piece of work.

Ultramarine and Burnt Sienna mix to a lovely gray.

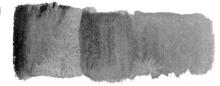

Adding white to red has created pink, which is a tint of red.

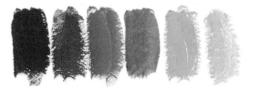

► For a warm gray, mix Ceruleum with Lemon Yellow and a touch of Magenta.

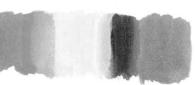

Color temperature

Reds, yellows, and oranges are usually thought of as warm colors, while blues, greens, and purples are cool. However, there are also warm and cool versions within each group. For example, Cadmium Yellow is a warm yellow because it is biased toward orange, and Lemon Yellow is a cooler yellow, biased toward green. Ceruleum is a cool greenbiased blue, whereas Ultramarine is a warm blue biased toward violet.

Cool colors recede while warm colors advance, so understanding color temperature will help you to create depth and recession in your landscape paintings. This doesn't mean that you shouldn't paint a red or yellow field in the distance, but modifying the colors to make them appear cooler will set them back in the landscape. When mixing secondary colors, the proportion of each individual primary that is used will determine the color temperature. For example, you can make a green appear cooler by adding more blue or make it warmer by adding more yellow.

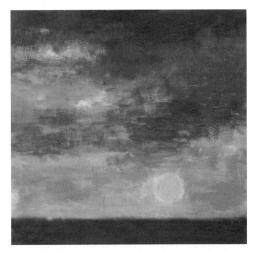

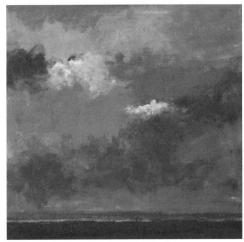

Sunset Study

The cooler reds and yellows of this sunset are high in the sky; lower down, as it nears the horizon, the sky gets warmer with oranges and bright vellows.

Sky Study This study shows warm and cool colors within the blue spectrum. Note that the sky gets warmer nearer the horizon.

QUICK TIP

You can knock back an area of warm tone by glazing it with a cooler color.

HALF-HOUR DEMO

Using color temperature

This painting shows how the use of cool and warm colors in a landscape gives the composition a feeling of recession, echoing the phenomenon of aerial perspective that causes colors to fade into blues and grays as we look into the far distance.

MATERIALS USED

Short flat brushes Nos. 4, 8; round brushes Nos. 6, 8; rigger No. 6 Bristol board Burnt Sienna Cadmium Orange Cadmium Yellow Ceruleum Flame Red ink Lemon Yellow Light Blue Violet Phthalo Blue (Green Shade) Titanium White Yellow Ochre

1 Using Burnt Sienna, loosely map out the main structure of the painting. Notice how the horizontal shapes are balanced by the verticals of the trees.

3 Next, paint the distant trees with a layer of Light Blue Violet to make them recede and bring much warmer yellow and orange into the foreground. Apply warmer green to the tips of the foliage on the tree.

2 Block in the dark tones and apply cool blue to the far trees. Lay a wash of Light Blue Violet over the sky. Paint the distant land Lemon Yellow and apply warmer orange-yellow to the foreground.

4 Paint the top half of the sky with Ceruleum and gradually add the warmer Light Blue Violet closer to the horizon. In the distance, add cooler blue-green to the foliage and the meadow.

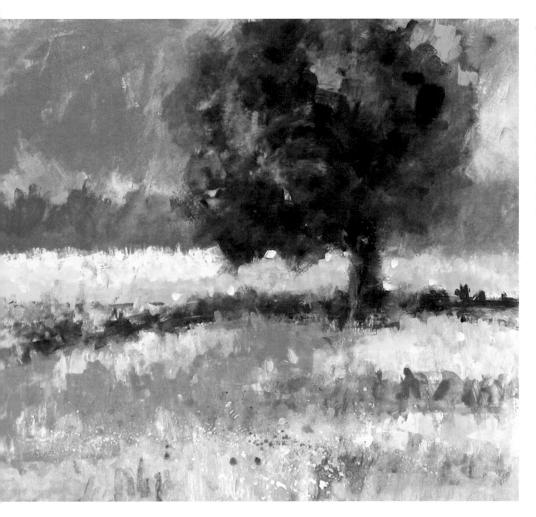

5 Make all the foreground colors stronger, thicker, and warmer to bring them further forward. Add more Burnt Sienna to the tree trunk and shape the foliage. Emphasize the cooler greens in the distance, then bring some cooler colors into the shadow areas in the foreground. Finally, splatter a little white and red to suggest summer flowers.

◄ Summer Landscape 10 × 11 in. (25 × 28 cm)

Tonal values

The tonal value of a color refers to its lightness or darkness. However, within individual colors this is a relative concept and the best way to grasp it is to compare the color against the gray scale below, which shows black all the way up to white, with all the shades of gray in between. For example, yellow at its highest saturation (darkest value) only compares to a light gray, whereas blue at its darkest value is comparable to a dark gray.

Tonal value is one of the most important design elements in a painting. When you are making a representational painting, to create a dynamic image, it is crucial not only to use the right local color of an object (for example a yellow banana) but also to use it at its correct value within the painting, which gives objects their dimension. Make light against dark against light your mantra; a painting that lacks tonal structure appears flat and lifeless, which in turn makes it not only boring but most of all unconvincing to the eye.

▲ This little exercise shows the value of colors against their gray value. Yellow at its highest intensity compares to the lightest gray, while blue at its highest intensity compares to a dark gray and crimson to a mid-gray.

▼ To assess the tonal value of a color, you can compare it to this nine-step gray value scale.

QUICK TIP

One of the best ways to judge the tonal value of your subject matter is to look at it through half-closed eyes.

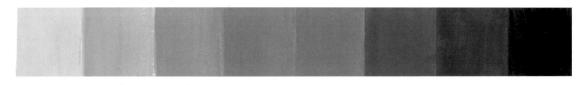

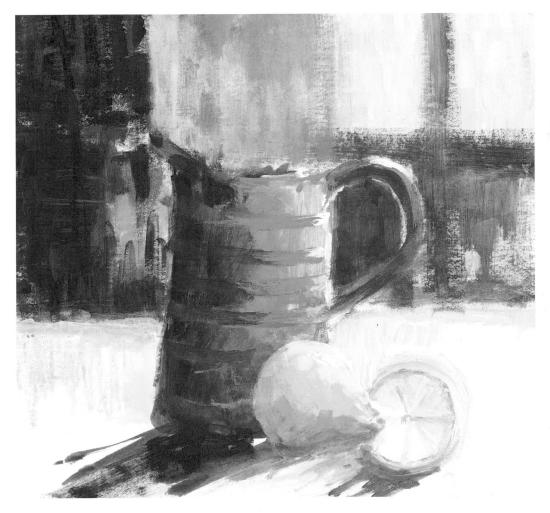

Still Life with Lemon

 10×10 in: $(25 \times 25$ cm) This backlit still life shows how the direction of light affects the tonal value of each object's local color.

Working in monochrome

It is often much easier to establish tonal values when you are working with pencils or charcoal—in other words, in black and white. Things can become slightly awry when color comes into the equation and confusion can set in. A good way of getting to grips with introducing the correct values when you are working in color is to practice by painting monochromes—that is, painting the subject with a single color, in its different tonal values.

It is amazing how removing the worry of an extended color palette allows you to concentrate on shape, form, and the correct tonal value, allowing you to start making convincing pictures. In time, this can be translated into color by comparing the local color of the elements in your painting against a gray scale to assess the correct tone. Remember to look at your subject through half-closed eyes, because this will reduce the details and break down the subject into light and dark values. With practice, this will become effortless and instinctive.

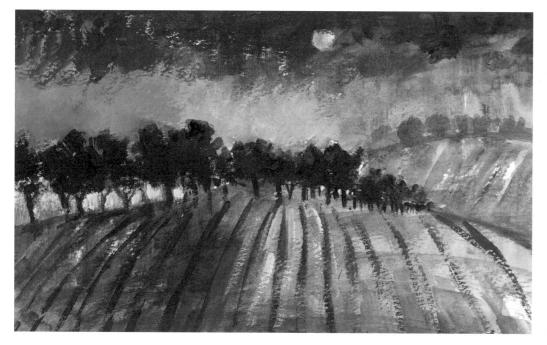

Moonlit Fields

 $6\% \times 10\%$ in. $(16 \times 27$ cm) I used Dioxazine Purple to do this little study. It was so much easier to judge the tonal values within the subject matter using just one color.

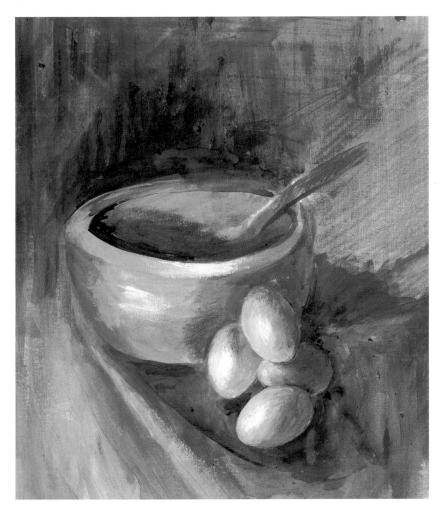

Kitchen Still Life

10 × 13 in. (25 × 33 cm) This still life was done in Sepia plus white and shows light, dark, and mid tones. The subject was lit from the left-hand side.

QUICK OVERVIEW

 Organize a basic color palette and become familiar with it.

□ Mix neutral grays from complementary colors, not black and white.

□ Use warm and cool colors to give depth to your pictures.

- □ Check the tonal values in your painting.
- □ Practice painting in monochrome.

PROJECT

Tonal values

To create a three-dimensional object, you need to depict it using the correct tonal values of its local color. No matter how beautifully you paint the elements within your picture, without the right tonal structure it won't convince the viewer and will become flat and one-dimensional.

Make a gray scale

Paint a nine-step gray scale (see page 24), starting with black and all the shades of gray all the way up to white. You can then compare the tonal values of your colors against their equal value on the gray scale. Through practice and experience you will become able to judge the correct tonal values instinctively.

Paint a still life

Arrange a simple still life and light it with a spotlight from one direction, so that you have a dramatic contrast between the lights and darks. Block in your lights, darks, and mid-tones without any outlines around the objects so that they are separated tonally. Place light against dark against light throughout the composition. If you find it difficult, start by painting it in monochrome. Repeat the same exercise, placing a still life on a table in the garden on a sunny day so that some objects are lit and some are in shadow. This time you will have less control over light and shade, so make a considered tonal study before going on to paint the scene in color. Because the light will change rapidly, it is also a good idea to make notes about light on your sketch and perhaps take a photograph to refer to later.

Tonal Study with Apple

8 × 9 in. (20 × 23 cm) This little study of an apple shows how the roundness of the fruit has been achieved by changing the tone. Directional light can create interest and drama in a painting.

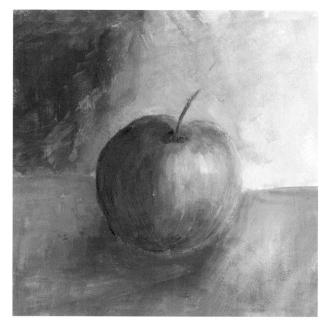

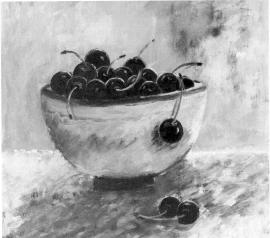

■ Garden Corner 10 × 12 in. (25 × 30 cm) This painting shows the different tones within a white object. Although the object is white, you only see it as such where it has been flooded with light.

Bowl of Cherries

 8×10 in. (20×25 cm) In this picture, you can see how the round shapes of the cherries have been represented by the change in the tonal value of their local color, which is a deep magenta. Changes in the tonal value also separate each cherry from the one next to it.

TECHNIQUES

Technique refers to the craft aspect of painting as opposed to the aesthetics, and it can be learned through sheer hard work and practice. The versatility of acrylic colors creates scope for a wide range of effective and exciting methods of applying them to various surfaces. You can dilute and use the pigments with watercolor techniques, such as wet-in-wet, or employ opaque techniques, such as impasto style or scumbling.

This chapter introduces a variety of these techniques, which can be used singly or in combination in your paintings. None is laborious, and you'll be able to create pictures in a short space of time.

Medley

 $11 \times 16\%$ in $(29 \times 42 \text{ cm})$ The collage shown here is composed of a few of my paintings that use techniques described within this chapter.

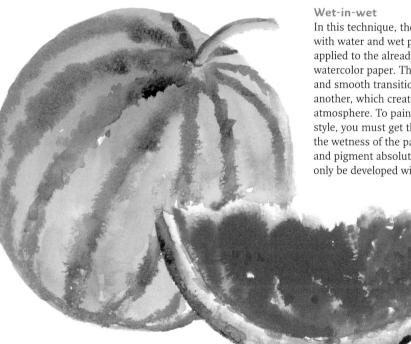

Watercolor technique

Acrylic colors can be diluted and applied in the style of watercolor washes. Acrylic inks and soft body colors are most suitable for this style of work.

In this technique, the brush is loaded with water and wet pigment and is applied to the already wetted surface of watercolor paper. This results in the soft and smooth transition of one color into another, which creates a great mood and atmosphere. To paint successfully in this style, you must get the balance between the wetness of the paper and the brush and pigment absolutely right, which can only be developed with plenty of practice.

Watermelons

I applied Dark Green ink to wet paper to shape the skin of the watermelon. I rewetted the area of fruit and, when I applied red ink, all the colors ran and fused together. While the paint was still wet, I put in the seeds with Payne's Gray.

QUICK TIP

For a smooth transition of paint wet-in-wet, load the brush and drop color onto the wet surface instead of brushing it on.

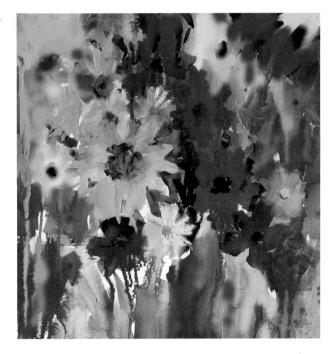

Sunflower

I dropped Bright Yellow ink onto wet paper to form the petals of this sunflower. Once this had dried, I rewetted the center of the flower and painted the shape of the center with a mixture of Bright Yellow and Purple Lake ink. ▶ Flower Fusion 15 × 16 in. (38 × 40 cm) After wetting the paper, I applied washes of color to each flowerhead. Once these had dried, I pulled the painting together by shaping some of the petals and applying more washes of ink.

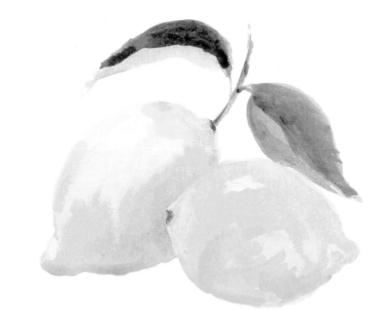

Wet-on-dry

Wet-on-dry is one of the most common ways of using water-based media. In this method, wet paint is applied onto dry paper or another layer of dry paint. This technique creates hard edges. It can also be used in combination with wet-in-wet technique if a painting requires both soft and hard edges. An acrylic wash of color becomes waterproof once it is dry, so the subsequent washes do not disturb each other and colors retain their vibrancy.

Lemons

I painted the lemons with Lemon Yellow, with Bright Yellow for the darker shadow areas and diluted Indigo behind the front lemon as shadow color. The leaves and the stem were painted in Olive Green, with Indigo added to the darker areas of the leaves.

▼ Little Sailor

8 × 12 in. (20 × 30 cm) My first step was to apply a wash of Indigo on the paper, saving white paper for the boat and sail. I added yellow, which mixed with the Indigo on paper to suggest the green of the bushes. Finally, I put some shadow on the boat and sail.

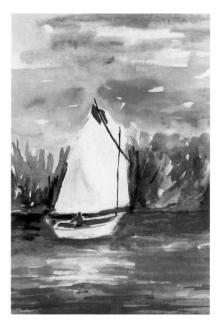

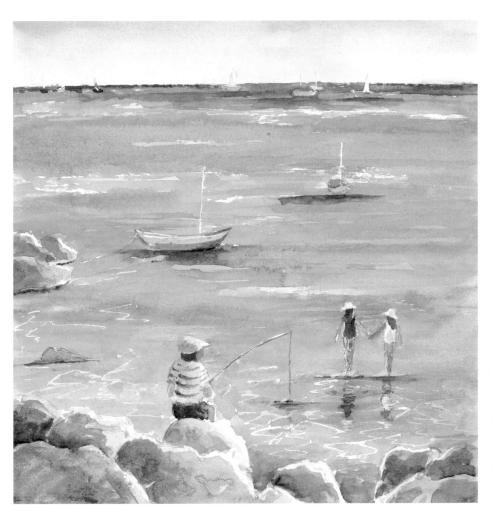

Children Fishing

12 × 12 in. (30 × 30 cm) I applied Ceruleum with touches of Lemon Yellow in the sea area. The rocks and the boats were painted with washes of Yellow Ochre and Burnt Sienna, building up the color from light to darker washes.

Opaque technique

It is great to take advantage of the heavy body quality of acrylic colors to paint in a variety of styles similar to oil painting without the problem of the lengthy drying time that oil pigments need. This is an ideal method for a beginner because mistakes can be easily rectified.

Impasto style

Applying thick color, with either a brush or a painting knife, so that it lies slightly raised from the paper is known as impasto. Acrylic colors are highly suitable for this way of painting because they dry quickly, allowing additional application of color in quick succession.

Heavier body acrylic colors are best for impasto because they retain the brushstrokes. Alternatively, you can add impasto gel or other bulking material to the thinner paints to make them suitable for impasto application. A third option is to use either texture gel or modeling paste to make a textured surface before applying any color.

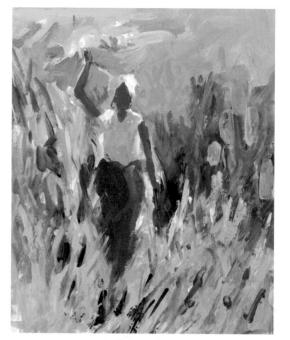

► Garlic

14 × 14 in. (38 × 38 cm) Super heavy body Titanium White and a dab of purple were used to give the garlic its bulbous shape and texture.

Walking Through the Field

 $9\%\times10\%$ in. (24× 27 cm)

Thick color has retained the brushstrokes and helps to create movement in this swift and spontaneous painting.

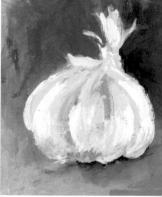

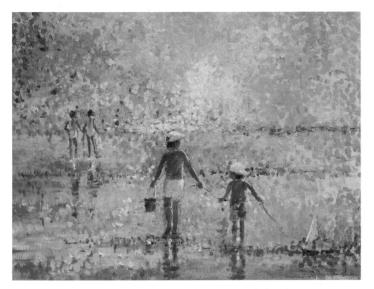

QUICK TIP

Keep your brushes in water during the painting session. Clean them often to keep colors fresh and vibrant. This will also help to keep the ferrules of the brushes cleaner over time.

▲ This detail of Midday Sun shows how the Yellow Ochre used as a base color can be seen through the final layers.

Broken color

Applying pigment in a way that allows some of the colors from the layer beneath to show through is an effective way of painting. You can either brush almost dry pigment over a base color or use dabs of color, leaving the base layer partly visible.

For maximum effect with this method, use complementary colors and take advantage of the fact that when the dabs of primary color are juxtaposed they will appear from a distance to be their secondary color.

🛦 Midday Sun

 16×20 in. $(40 \times 51$ cm) The complementary colors yellow and purple, applied in dabs, create a good contrast in this painting. The whole color scheme was designed to create harmony.

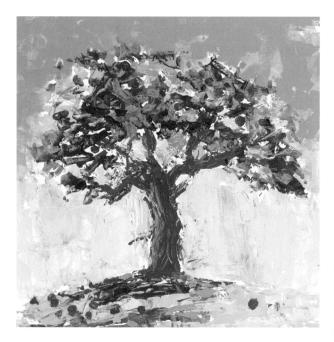

QUICK TIP

When applying paint with a painting knife, wait for each layer to dry before adding another one to avoid muddy colors.

▲ Apple Tree 9×9 in. (23×23 cm) I painted the bark with Burnt Umber, then applied a mixture of dark and light green for the foliage and the grass in the foreground. Once these layers had dried, I added the apples in dabs of bright red.

Using a painting knife Applying paint with a painting knife is a tactile and enjoyable way of working. The marks made are different from those of a brush and the effects are much more random and less stylized, making it easier to create semiabstract images.

To achieve this technique successfully, you need the heavier body acrylic colors, and super heavy body acrylics are even better. Depending upon the shape of your painting knife, you can use long, sweeping strokes or shorter, more controlled marks. You can scratch into the thick paint and create texture at the same time.

▼ Vary the type of marks you make to create a more interesting image.

◄ Flower Field 10½×12 in. (27 × 30 cm) I laid a layer of dark green over the background trees and made a diagonal pattern of dark colors in the foreground. Once that had dried, I applied thick layers of lime green, white, light blue, and magenta in dabs of color to suggest the flower meadow. ▲ In this detail of *Flower Field*, you can see how I have scratched into the paint to suggest the stems.

Combining transparent and opaque colors

Using a combination of transparent and opaque colors is one of the most rewarding ways in which to paint with acrylics. Transparent washes of color in either acrylic ink or diluted tube color provide translucent passages in the painting, which create depth and recession, while the thicker application of color can provide textural effects. Transparent colors can also be used at the later stages to glaze an area for a change of color and tonal values. The marriage of the two creates a more rounded and interesting painting than one where only a single paint quality is used.

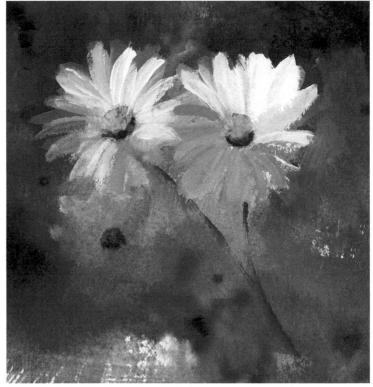

Geraniums
Here, I first used opaque paint and then applied transparent glazes as cast shadow to create a sunny feel. ▲ Daisies 6×6 in. (15 × 15 cm) In this painting of daisies, the transparent colors set the scene with the dark background. I painted the daisies in heavier textured Titanium White where the light hits them and used light gray where they are in shadow.

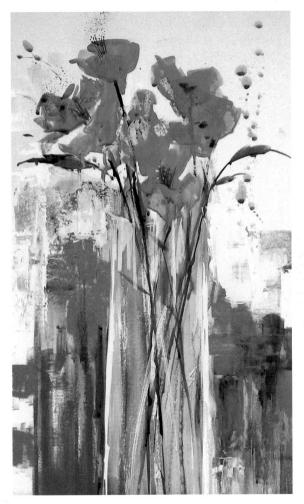

Lilies in Tall Vase

12 × 19 in. (30 × 48 cm) In this painting of lilies, the delicacy of their petals is suggested with the translucency of inks. I rendered the more solid vase and the background using thicker, more textured paint.

▼ This detail of *Lilies in Tall Vase* shows how I scraped opaque white over the ink to create a more solid effect.

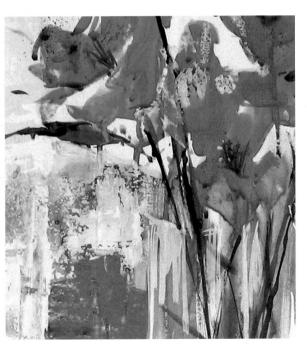

HALF-HOUR DEMO

Transparent and opaque colors

In this demonstration, washes of ink provide a tinted background of translucent color, which recedes. The heavier body colors are used for the textured passages in the foreground, the combination of the two creating depth and recession.

MATERIALS USED

1-inch (25-mm) synthetic watercolor wash brush No. 8 round synthetic watercolor brush ½-inch (12 mm) flat brush No. 6 rigger Bristol board or watercolor paper Acrylic inks: Flame Orange Lemon Yellow Prussian Blue (Hue) Heavy body tube color: Bright Aqua Green Burnt Sienna Burnt Umber Lemon Yellow Light Blue Violet Phthalo Blue (Green Shade) Titanium White

1 Wet the paper with clean water, using your wash brush, then lay Lemon Yellow ink over the whole surface. Apply Flame Orange ink to the middle section and the lower part of the paper in a hit-and-miss fashion. Let dry, or use a hair drier to speed up the process.

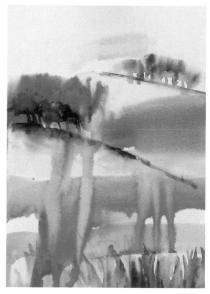

2 Rewet the top right-hand corner and, using your No. 8 round brush, drop Prussian Blue ink onto the wet surface and let it disperse instead of brushing it on. Repeat the same procedure on the left-hand side. Dampen the bottom of the paper and brush in a mix of Prussian Blue and Lemon Yellow inks, dragging the brush up to form leaf shapes in the foreground.

3 In the top right-hand corner beneath the trees, make furrows with Prussian Blue ink. Mix a dark green with Phthalo Blue, Lemon Yellow, and Burnt Sienna in thicker paint for the nearer trees and the foreground plants. Scumble Light Blue Violet over the field in the front. Let dry, then scumble a layer of Bright Aqua Green over the same area.

4 Finally, paint the sheep with a mix of Light Blue Violet and Titanium White and apply thicker paint to shape the foliage in the foreground plants.

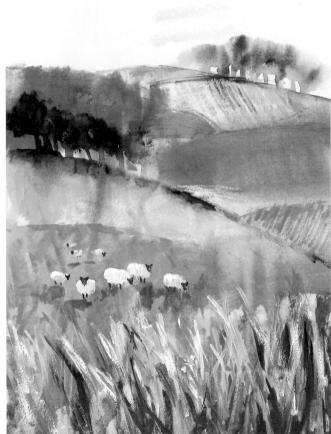

Fieldswith Sheep9 × 12 in. (23 × 30 cm)

Blending

Blending is the technique of diffusing one area of color and tone into another. The fast-drying nature of acrylics requires you to act quickly in order to achieve this successfully, but applying a few drops of paint retarder or slow-drying medium will give you slightly more time. The thicker the area of color the easier the blending process is.

This method is useful for lost-andfound passages in a painting, where you need to lose edges or where gradation of tone is necessary.

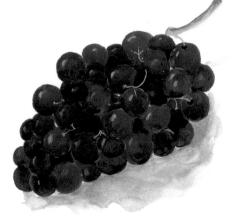

Pomegranate

 8×8 in. (20 \times 20 cm) Gradation of color on the skin was necessary to give the fruit its round shape. I blended the color in the area of highlight and the gradation of darker to lighter tones.

▼ Grapes

Several thin layers of Crimson and Purple Lake ink form the individual grapes. In the shadow areas, I painted them first with a thin glaze of Ultramarine tube color in order to make them recede.

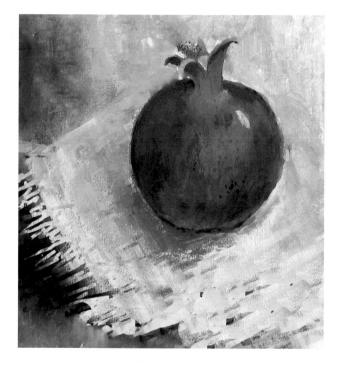

Glazing

Glazing, done by applying multiple thin layers of transparent or semitransparent color on top of each other, creates amazing depth and richness of color. You can also glaze at the later stages over opaque paint, which is the technique more frequently employed with acrylic pigments. This is especially useful to correct the value or intensity of color for example, a warm color in the background can be glazed with a thin layer of a cooler color to make it recede. Always let each layer dry before applying another one on top.

Scumbling

Scumbling is a technique that comes under the umbrella of "broken color." It means glazing color by using almost dry semitransparent or opaque color on top of another color, allowing the underlying layers to show through and thus creating a broken color effect. This method can be used to knock back areas of bright color and is also effective in representing a smoky or hazy atmosphere.

QUICK TIP

Adding either matte or gloss medium to paint increases its transparency and makes it more suitable for glazing.

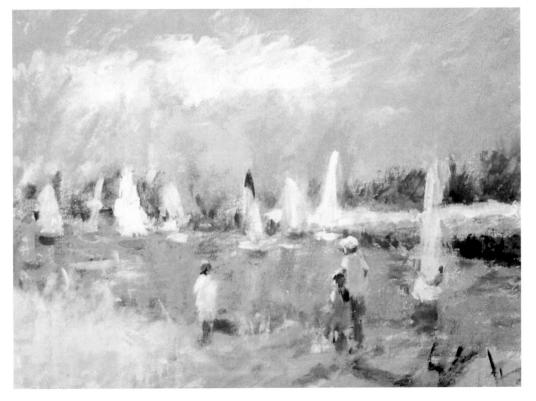

◀ Children's Boat Race

 8×10 in. $(20 \times 25$ cm) In this painting, I scumbled Titanium White and Buff Titanium over the sky to form clouds. In the foreground, the same treatment created the feel of a hazy day.

PROJECT

Watercolor and opaque style

Offering a choice of transparent washes of color, thickly textured applications, or a combination of the two, acrylics give the artist greater freedom of expression than any other medium. This project will encourage you to explore their possibilities.

Experiment with paint Choose a favorite subject that lends itself to a combination of watercolor and opaque techniques. Try applying washes of transparent color as the underpainting and allow some of the washes to show through the subsequent layers; the watercolor passages will recede and the heavier texture areas will come forward, creating depth and recession in the painting.

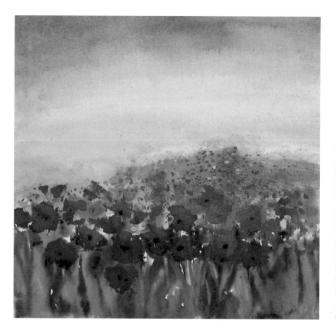

Poppy Fields

10 × 10 in. (25 × 25 cm) In this picture, I chose to paint the sky and the distant fields in ink washes that make them recede. I applied a combination of watercolor and opaque style to the red poppies and the foliage in the foreground so that some appear to be more distant and others advance.

Another good exercise with acrylics is to paint your subject matter once in the style of watercolor and once using an opaque technique. You can also repeat the same subject, applying different techniques in watercolor, such as wetin-wet or wet-on-dry, and a few different opaque techniques, such as impasto or scumbling. This very useful exercise will teach you how to judge which style to choose for particular subjects in order to create the maximum impact in your painting.

Finally, choose a subject and start off by applying transparent washes of color, then go on to add heavier texture acrylics. Repeat the same subject but this time begin by using heavier texture acrylics, then change or modify some areas by glazes of transparent color. This is particularly useful for shadows or toning down areas of bright colors.

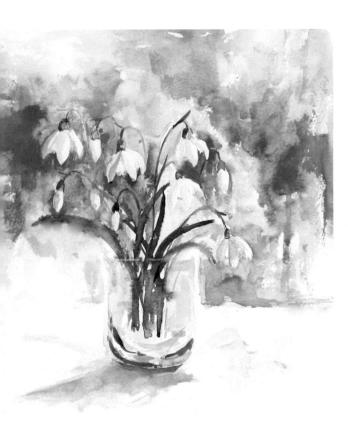

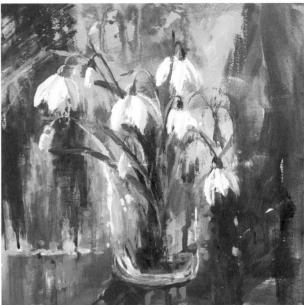

■ Snowdrops 1 10 × 10 in. (25 × 25 cm) I made a few outlines of the snowdrops to save the white paper for their petals. I applied water around the flower heads, laid down Ceruleum and Ultramarine in the surrounding area, then added shadow colors to the flowers afterward.

Snowdrops 2

 10×10 in. $(25 \times 25$ cm) In contrast to the watercolor style shown left, in this painting I applied opaque Ceruleum and Ultramarine and established a dark background first. I then painted in the darker tones of the flowers before adding the white highlights.

Using other tools

Acrylic paints can be applied using other tools, and each implement will result in a different finish. For example, a roller flattens the color and the result is totally unlike that of paint laid by a brush. Scraping paint using a credit card is another option—it has a hit-and-miss effect, which allows the layers underneath to show through and make attractive abstract shapes. The edge of the card dipped in ink is also great for drawing straight lines. If you try using various tools, no matter how unlikely they seem, you will enlarge your repertoire of effects.

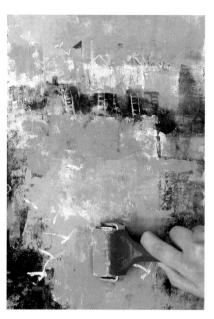

▲ This painting was built up by using a roller, apart from a few brushstrokes to finish off the beach huts. It was quick, a lot of fun, and effective. You must wait for each layer to dry before applying another one.

► The Red Beach Ball 14 × 18 in. (35 × 46 cm)

My technique for this painting was to scrape on a layer of paint with a credit card, let it dry, and then scrape another one on top. I used the edge of the card dipped in paint to depict the straight lines of the windbreaks.

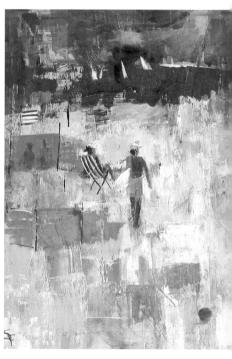

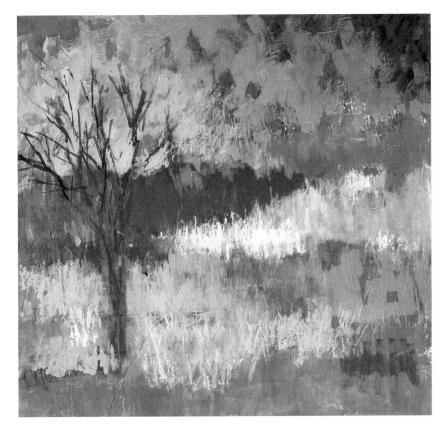

Field Patterns

 14×14 in. (35 \times 35 cm) In this painting, I blocked in some colors and shapes, first using acrylic color and then highlighted areas with pastel applied over the top.

Acrylic with other mediums

Acrylic color makes a very receptive surface on which to apply other mediums. Oil painters have used acrylic as a base for many years. It also makes a great base for oil and soft pastels. Applying a layer of acrylic or acrylic primer (gesso) can create tooth on a smooth cardboard, making it an ideal surface for pastel.

QUICK OVERVIEW

□ Combine translucent washes with opaque color for interesting paintings.

□ Glaze with translucent layers of pigment to add depth and richness to your painting.

□ Create broken color, either with brushstrokes or by scumbling.

□ Use a variety of tools to apply your paint so that you create different effects.

CREATING TEXTURES

The heavy body of acrylic colors makes them ideal for creating textural effects, either for particular surfaces, such as grass or stone walls, or for abstract or semiabstract passages within a painting. Super heavy body colors can retain brushstrokes or the marks made by a painting knife or other tools, and you can also experiment with a wide variety of texture-making products in combination with the paints.

In this chapter, you will discover a few of the many ways in which you can push the boundaries with texture and see how quickly exciting surfaces can be created with this medium.

Textured Abstract

 $9\% \times 12$ in. $(24 \times 30$ cm) In this painting, I have used a variety of materials, such as texture paste, tissue paper, splattering, and stamp to create texture and pattern.

Using thick acrylic color

Super heavy body acrylics are the most suited to creating textural effects with paint alone. Use plenty of pigment with very little water so that the paint can retain the brushstrokes or marks from any other tool that you are using to make texture. A metal brush, comb, or painting knife are all ideal to use for this. Grass, stone walls, rocks, and animal fur are a few of the possible textures you can suggest with this method.

► Furrowed Field

 $8\% \times 10\%$ in. (21 \times 26 cm) In this painting, I used System 3D Yellow Ochre as a base color, then painted the field in Burnt Umber. I scratched out the furrows in the field with a metal comb to reveal some of the ochre from underneath.

Using texture paste

You can also choose from a wide range of texture-making products, such as texture paste, modeling paste, ceramic stucco, natural sand, glass beads, and so forth. For the best results, apply the paste to your support with a painting knife and create the texture you want, then let it dry completely before you paint on the surface. In a representational landscape, reduce the textural effects toward the background to add to the feeling of recession.

◀ Seagull on the Stone Wall 6½ × 9 in. (16 × 23 cm) I used ceramic stucco to create the texture of the stone wall with a fairly small knife, then painted it with a mixture of ink and tube color.

■ Rock Patterns 10¼ × 11½ in. (26 × 29 cm)

I used texture paste to shape the rocks and pressed fabric to the paste on the trees to suggest foliage. I painted the picture mainly with ink.

QUICK TIP

It is much easier to shape the paste with a painting knife, which is also easier to clean afterward than a brush.

Using simple collage

Using collage on your painting support breaks up the surface, so you no longer have a daunting piece of white paper waiting for your first mark. You can create different textures by using various types of handmade paper, tissue paper, newspaper text, textiles, imitation gold leaf, and so on.

Collage is particularly useful if you want to work in a semiabstract or abstract fashion. You can apply your materials randomly and then manipulate the shapes to suit your subject matter or however you think they might be effective. V Collage materials

A selection of collage materials might include tissue paper, handmade paper, leaf skeletons, imitation gold leaf, and newspaper text.

A Greek Buildings

(detail)

Pieces of handmade paper and tissue paper create the random shapes of the buildings. The texture on the handmade paper is ideal to suggest the rough walls of the building.

Boat Race 7 × 10 in. (18 × 25 cm)

In this painting, I used magazine cutouts and colored paper to shape the sails and tissue paper for the texture in the sea area.

QUICK TIP

Apply collage with slightly diluted white glue, using an old brush. It is important to let the collage dry completely before painting.

PROJECT

Exploring different textures

The heavy body of acrylic colors makes them ideal for creating interesting textures. You can manipulate the paint to give texture or add other material to the paint. In this project, let your imagination run wild.

What to do

Find objects that can be used as a tool to make texture on thick paint, such as a metal brush, a comb, and so forth. Look also for a variety of objects that can leave an interesting imprint on thick paint or gel medium, such as bubble wrap, fruit netting, metal mesh, or various types of fabric.

Collect some materials that can be added to the paints to create texture, such as texture paste, modeling paste, natural sand, and glass beads. Materials such as tissue paper and handmade paper can be glued to your paper with white glue prior to painting to produce a textured ground. Plastic wrap, wax resist, masking fluids, oil pastels, stamps, and stencils can all be used successfully with acrylic inks to create interesting effects.

Experiment with texture

Draw a $3\frac{1}{4} \times 3\frac{1}{4}$ inch (8 × 8 cm) grid on your paper and experiment with a different type of texture in each square to build a library of reference materials. Finally, choose a subject on which to try out a few of your textures.

Don't use too many different textures, and balance a busy area with a quiet passage. In a representational painting, keep heavily textured areas in the foreground and reduce texture toward the background to create depth.

Spattering

After masking the daisies, ink was spattered with an old toothbrush to create a textured background.

🛦 Wax resist

The swirl was painted with oil pastel, which then resisted the ink wash effectively.

A Tissue paper

Tissue paper was glued to the surface with white glue. Allow it to dry before painting on it.

▲ **Bubble wrap** A piece of bubble wrap pressed on a wash of strong ink left a characteristic imprint.

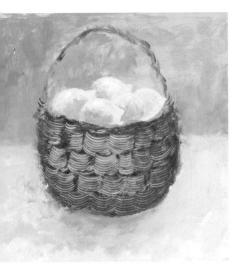

A Basket of Lemons

8 × 8 in. (20 × 20 cm) After applying a layer of Yellow Ochre and letting it dry, I painted this over with Burnt Sienna and used a metal comb to create the weave of the basket.

▶ Laundry Line, Venice

 $8\% \times 10$ in. $(21 \times 25$ cm) Here I used natural sand and newsprint on the walls, tissue paper for the clothes on the line, and handmade paper on the shutters.

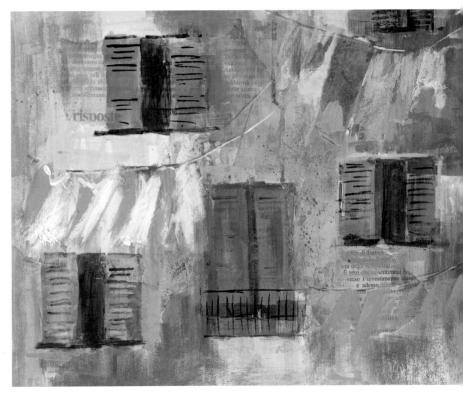

QUICK STUDIES

When you are starting out it is important not to bombard yourself with too many details at once; otherwise, you might be overwhelmed. Making quick studies will help you to tackle the individual elements and objects that collectively make a complete painting, so this chapter concentrates on one single idea without the complication of composition and other factors.

These quick little studies can be charming and will make a wonderful reference library for you to refer to when attempting bigger, more complex paintings.

Still Life with Cherries

 $8\% \times 10\%$ in. (21 \times 27 cm) This quick study of a still life, done with ink and oil pastel, is a reference for a future painting.

Flowers and leaves

Flowers give you the opportunity to play with color to explore their amazing and intricate forms. To begin with, don't make things difficult for yourself with complicated arrangements—just concentrate on a single bloom.

During the summer months, you can fill a whole sketch pad with all the popular garden plants. In time, you will decide which flower will benefit from being painted with inks in watercolor style, for example red poppies and anemones, and which are best with thick acrylic color, such as daisies. Some, including sunflowers, are best suited to a combination of the two.

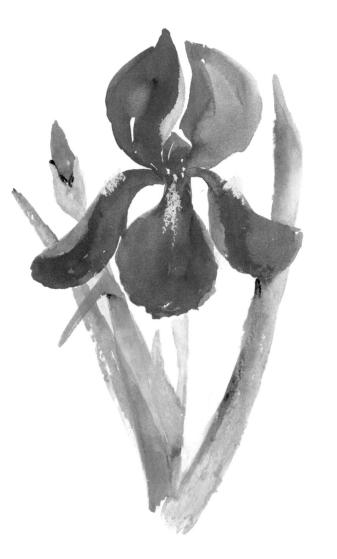

▶ Iris

For the iris I used Dioxazine Purple tube color and some Indigo ink in a combination of thick and thin application. The large petals of iris are fun to paint. I applied a dab of thick yellow for the center of the petal.

▼ Ivy

To paint the ivy leaf, I used oil pastel as a resist before applying Dark Green ink, giving the impression of a variegated leaf.

Red Poppies

7 × 9 in (18 × 23 cm) I used Flame Red, Bright Yellow, and Process Magenta ink on the petals in a combination of wet-in-wet and wet-on-dry style. I used Olive Green ink in the background and let the colors run and mingle. ▲ Maple

This maple leaf was painted with Crimson, Flame Orange, and a few drops of Burnt Umber ink.

▲ **Holly** I used Dark Green ink to paint the holly leaf and Flame Red for the berry.

Landscape details

Trees play a big part in landscape paintings, so a close observation of the individual shapes of different species and how they grow is important. Pay close attention to the shape of the trunk and the overall outline of the tree.

In most landscape paintings, it is best to make merely a suggestion of foliage and treat it as a mass instead of painting every leaf. A rigger brush is useful for painting the branches. Details, such as fir cones, berries, and birds' nests can feature in a small-scale landscape painting but are all interesting subjects on their own, too.

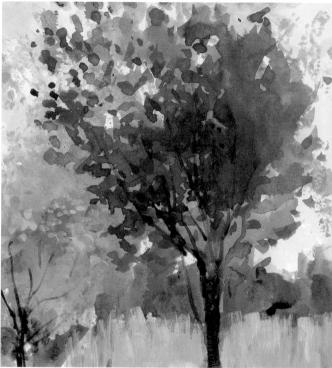

▲ Copper Beech 5½ × 5½ in. (14 × 14 cm) Once I had put in the overall shape of the tree, I used numerous dabs of Purple Lake and Crimson ink to suggest the foliage.

Olive Tree

 $4\frac{1}{2} \times 6$ in. $(14 \times 15$ cm) I love the crooked branches and bluegreen pointed leaves of the olive tree. I painted the trunk with thick pigment and used a mixture of green and blue ink for the foliage.

V Fir Cone

I painted this fir cone with diluted Burnt Umber. Before the paint dried, I lifted some color with the tip of a clean, dry brush to shape the scales. **Berries** I used Crimson and Flame Red ink in the glazing method to paint the berries and suggest the round shapes.

Bird's Nest

After using heavy body acrylic to paint the bird's nest, I dragged light Yellow Ochre over the dark color to create the weave of the nest.

Water and boats

Water, with its reflective surface quality, is one of the most challenging subjects for the artist. It mirrors the environment and it is highly affected by the changing light and the climate; a gentle breeze can easily break a mirror reflection into a fractured one in seconds.

The opacity of the pigments, the richness of the colors, and the availability of an opaque white makes acrylic an ideal medium for painting waterscapes, such as rivers, waterfalls, lakes, and the sea.

▶ Waterfall

6% × 6% in. (16 × 17 cm) Yellow Ochre and Olive Green inks defined the area surrounding the fall, and I applied Indigo underneath it to create a dark background for the water. Finally, I used Titanium White acrylic color to suggest the water.

In mirror reflections, make the reflected image darker in value by glazing a layer of gray-blue wash over it. This will soften the image and makes it more convincing.

I first made a loose outline of the dinghy, then I used mainly thick opaque color to paint this little study.

► Sea and Rocks 4 × 5½ in. (10 × 14 cm I used Yellow Ochre ink to establish the

> rocks and painted the rest of this little study with tube color. I applied white acrylic ink to suggest the splash of waves against the rocks.

Objects

Of all subjects for the artist, inanimate objects are the least problematic; not only are they static, but an interesting range of them can be found in abundance in any home.

Painting a single object, or a few related ones, is good practice for the time when you want to include them in a bigger painting. Their shapes fall into four categories of sphere, cone, cylinder, or cube, and they will train your eye for judging the right tonal values and the relationship between different shapes. Items in the kitchen or on the coffee table, however ordinary, make ideal doodling material and are great practice for future still life paintings.

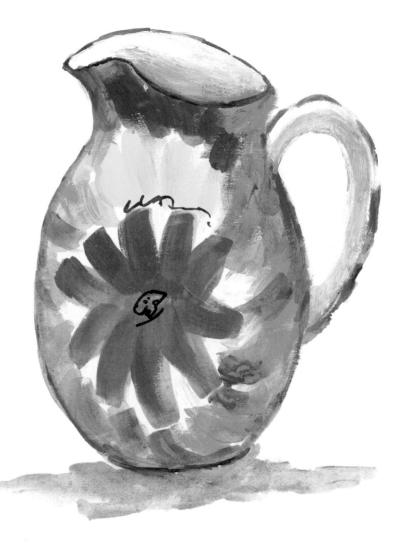

Spanish Pitcher I used a combination of watercolor and opaque techniques to make a swift painting of this bright, handdecorated pitcher.

▼ Beach Bag and Sun Hat

This simple little study of a beach bag and hat can be incorporated in beach and seaside paintings. I used thick acrylic color to paint it.

For this very quick study of my bedroom chair with its Indian cushions, acrylic inks in watercolor style were ideal.

Animals and birds

Farm animals and wildlife provide a huge range of subject matter for the artist. However, they are difficult to paint from life unless you are an experienced wildlife artist, and this is a time when photographs can be a useful aid, as long as you avoid the trap of just copying them. Acrylics make an excellent medium for painting animals, because you can first establish the overall shape with diluted color and then move on to creating different textures of hair, feathers, and skin with thicker colors. The vibrant colors of acrylic inks are ideal for painting all types of colorful birds, butterflies, and sea creatures.

> Mother and Child The woolly coat of sheep is best described in thick acrylic color. I used Unbleached Titanium White, light blue for shadow colors, and Titanium White for the highlights.

▶ Parrot

The wonderful bright feathers of parrots are great to paint in acrylic colors. I used Flame Red, Process Cyan, and Light Green ink with weton-dry technique to paint this bird.

▶ Cockerel

I used a combination of opaque and transparent colors to paint the cockerel; the main body was done in thicker paint and the tail with acrylic inks. The dry-brush technique is ideal for feathers, using a lot of pigment with very little water.

QUICK TIP

A comber or fan brush is ideal for depicting animal fur or birds' feathers. Make a light color wash over the area first, then use opaque paint.

Figures

The human figure is by far the most challenging of all subjects, but acrylic paint is a great medium for painting it because you can correct any mistakes. Knowing this will give you confidence to go ahead and try, however daunting you may find it.

Although people come in different shapes and sizes, the proportion for the average figure is around 7–7½ heads tall, and to paint convincing figures this proportion needs to be right. Practice by doing many quick little gesture drawings with a lot of energy and movement, so that when you try to include figures in your compositions you can draw from this experience. If there is a local life drawing class you can attend, it will not only help you with figure painting but improve your drawing skills generally.

▶ The Waiter

(detail) Uniforms give immediate identity to a figure, and waiters are one of my most favorite subjects. I used opaque colors for this little study.

▼ Girl by the Sea

Although the figure is standing still, the feeling of movement through the hair and the skirt stops it from being totally static. I used a combination of thick and diluted color for this figure.

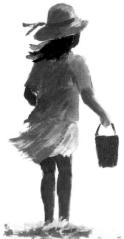

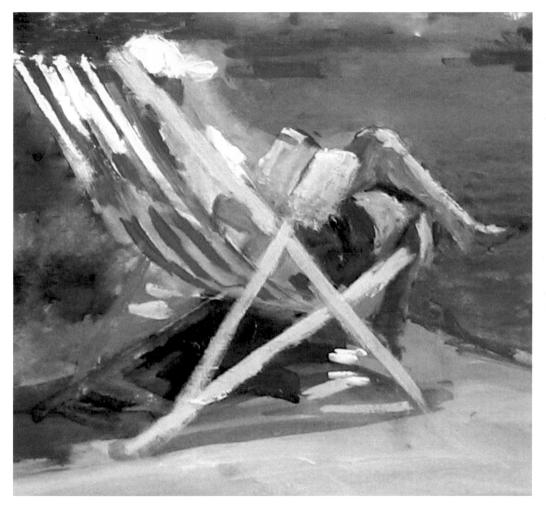

Deckchair

(detail) For this painting, I used thick color. The figure is facing away from us, which makes it a bit more intriguing.

▼ Tuscany Villas

4 × 9 in. (10 × 23 cm) Buildings that are of different height and appearance make a more interesting arrangement than uniform ones. I used some Yellow Ochre ink to give an overall warm glow to the buildings and Dark Green ink on the foliage of the surrounding trees.

Buildings

Perspective is the most challenging aspect of painting architectural subjects. If the focal point of your painting is the buildings, perspective should be carefully considered. If this is something you find difficult, simplifying the buildings will usually make it less problematic. Start with simple subjects, such as a doorway or a window box, before tackling entire buildings. In the case of a complicated building, try not to paint every window and leave some of the details to the imagination of the viewer. Once again, the opacity of acrylics will come to the rescue if you make any errors because you can easily correct them.

▶ French Window Box

 7×8 in. $(18 \times 20$ cm) Details of buildings, such as windows and doorways, often make interesting subject matter. This window box was painted mainly with acrylic inks.

Old Doorway

6 × 8 in. (15 × 20 cm) Attractive old doorways make lovely subjects. I applied several glazes of Burnt Umber and Red Earth ink to paint the door and spread the ink further to the surrounding area.

QUICK OVERVIEW

□ To begin with, concentrate on a single element within a range of different subjects.

□ Paint variations on a single idea, such as different species of flowers or trees.

□ Make a useful reference library of these to include in future paintings.

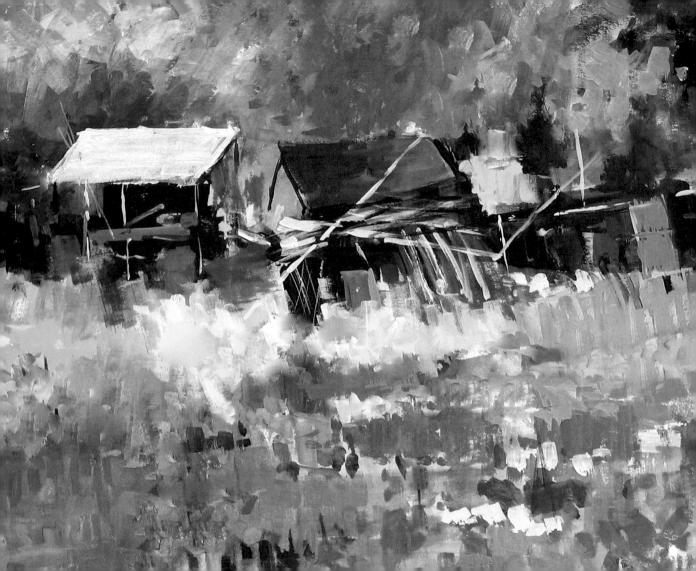

COMPOSING YOUR PICTURE

Composition is the framework upon which your subject matter is built. A good composition will attract the viewer and hold their attention; a bad one can make the painting at best simply boring and at worst visually disturbing.

This chapter covers a few fundamental elements regarding composition. While the experienced artist is able to break all the rules and get away with it, if you are a beginner, it is better to follow these guidelines because they will help you to create a more integrated and dynamic painting.

In Derelict Barns

 14×16 in: $(35 \times 41$ cm) In this composition, the emphasis is on the foreground, with the buildings creating the busy part of the picture.

Compositional rules

Following the tips given here will help you make interesting and balanced compositions. Your aim is to lead the viewer's eye around the painting and to create a point of main focus.

Simplify your reference material and eliminate any unnecessary or unwanted detail that exists.

Divide your picture space into unequal segments, and vary the proportion and importance of objects.

Follow the rule of thirds (see below).

In landscapes, have a large area of either sky or land—do not place the horizon line in the middle because this cuts the painting in half.

 In aerial perspective, warm colors come forward and cooler colors recede.
 Use this to create depth in your painting.
 In still lifes, overlap the objects instead

of placing them side by side so that they just touch.

Compose the picture with attention to the tonal values as well as the elements within the subject.

Lead the eye into your painting with linear elements, such as walks and walls.

Make odd numbers of key elements for example, three sheep instead of two in a landscape.

Pay careful attention to the negative spaces around the subject. These are just as important to the composition as the positive shapes and need to be just as interesting.

The introduction of too many isolated figures divides the focus of interest, with each one vying for the viewer's attention. Grouping some of the figures together and balancing them with a few strategically placed single figures makes a better composition.

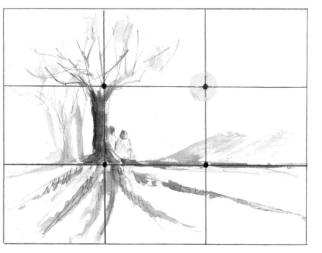

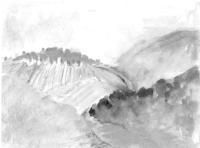

▲ Devise ways of leading the viewer's eye into and through the painting.

Divide your paper into thirds vertically and horizontally. Each intersection of the dividing lines makes a suitable area for the focal point of your painting (known as the rule of thirds).

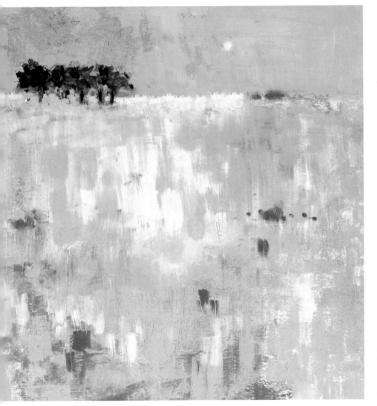

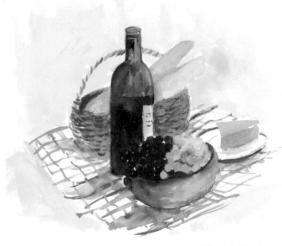

A French Picnic

 10×12 in. $(25 \times 30$ cm) In this still life, the objects relate to each other; they are grouped together to make a more dynamic composition.

Summer Fields

 10×10 in. $(25 \times 25$ cm) This painting is about the texture of the field in the foreground. By having a smaller sky, I have avoided cutting the painting in half.

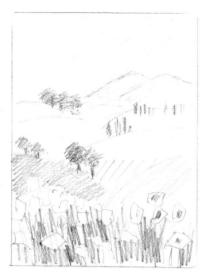

▲ This is the thumbnail sketch I made for *Provence Landscape* (opposite) while I was deciding whether to have a portrait or landscape format.

▶ In this second sketch, I tried the landscape format, but decided that I liked the portrait format better.

Thumbnail sketches

Don't plan to fail by failing to plan! Thumbnail sketches are the most efficient way of planning for a painting. These are small, roughly drawn sketches that require just a few minutes to work out the structure of your painting.

In your sketch pad, draw four or five small boxes the same shape as your paper or canvas. Within this small format, you can simplify the subject matter, work out your tonal values, compose your picture, and decide on a landscape, portrait, or square format. A little planning goes a long way to avoid frustration at a later stage and to help you make a better painting.

In this quick little sketch for Flower Market (see p. 93), I have blocked in all my shapes and tonal values.

QUICK TIP

Use a black water-soluble pen or pencil to do your thumbnail sketch, then add water with a brush to create a tonal study.

Using an underpainting

Making an underpainting has several advantages, not least that it banishes the whiteness of paper or canvas that some artists find most disconcerting. It can be used to set a certain mood or ambience for the whole picture—for example, an underpainting of cool grays and blues is ideal for painting a rainy day. You can also use underpainting to block in your darks, lights, and mid-tones before you paint any details of the composition.

Underpainting does not have to be in monochrome; a colorful underpainting that shows through subsequent layers can create a visual feast. Underpainting in complementary colors can create strong visual contrasts—where you have areas of foliage, try using red as underpainting, or apply orange as an underpainting for the blue of the sea. With acrylic colors, you have the option of using a combination of thick and diluted paint or washes of ink to create transparent passages that will recede and add depth.

▲ I used a cool and warm yellow as an underpainting for *Provence Landscape*, with a dash of orange to create a sunny feel.

Provence Landscape 10 × 12 in. (25 × 30 cm)

Allowing the yellow underpainting to show through the top layers provides harmony and cohesion within the whole painting as well as creating a sunny ambience.

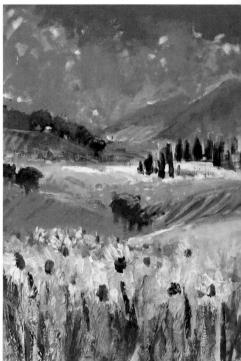

HALF-HOUR DEMO

Underpainting

In this demonstration, Ultramarine underpainting helps to create the darker values of the colors that will be applied on top. The Lemon Yellow gives a sunny glow to the background and the lighter sides of the apples, and by letting it show through the subsequent layers, uniformity and harmony are created in the painting.

MATERIALS USED

Short flat brushes Nos. 4, 6, 8 Round brushes Nos. 2, 4 Daler-Rowney Langton 140 lb. (300 gsm) Cold-Pressed paper Bright Green Burnt Sienna Cadmium Red Lemon Yellow Light Blue Violet Quinacridone Deep Purple Titanium White Ultramarine

1 Using Ultramarine and a No. 4 round brush, sketch out the basic plan, using a diagonal composition that will lead the viewer's eye from the red apple at top left to rest on the green apple at the bottom.

3 Apply Ultramarine to the top left-hand side to suggest a darker area and Bright Green to the right-hand side to show lighter foliage and to the green apples. Paint the windowsill with Light Blue Violet and the window pane with a neutral gray.

2 Apply an underpainting of Lemon Yellow to give an overall sunny feel to the background and the light streaming through the window. Using Ultramarine, block in some of the darker values.

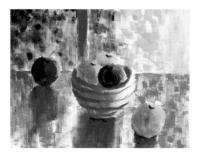

4 Paint the red apples with Quinacridone Deep Purple and a touch of Cadmium Red, leaving the sunlit side lighter. Using Ultramarine and Burnt Sienna, put in the stalks. Use random brushstrokes to suggest foliage in the background.

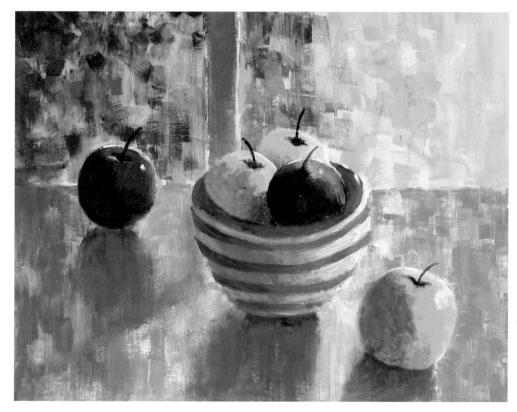

5 Give the red apples more form and definition with a few glazes of Quinacridone Deep Purple and Cadmium Red and use Bright Green in the case of the green apples. The yellow and blue underpainting helps a great deal with establishing tone in the first place. Strengthen the shadows under the objects and add lighter tones to the windowsill. Finally, paint the stalks and add highlights to finish the picture. ▲ Apples on a
 Windowsill
 9 × 10 in. (23 × 25 cm)

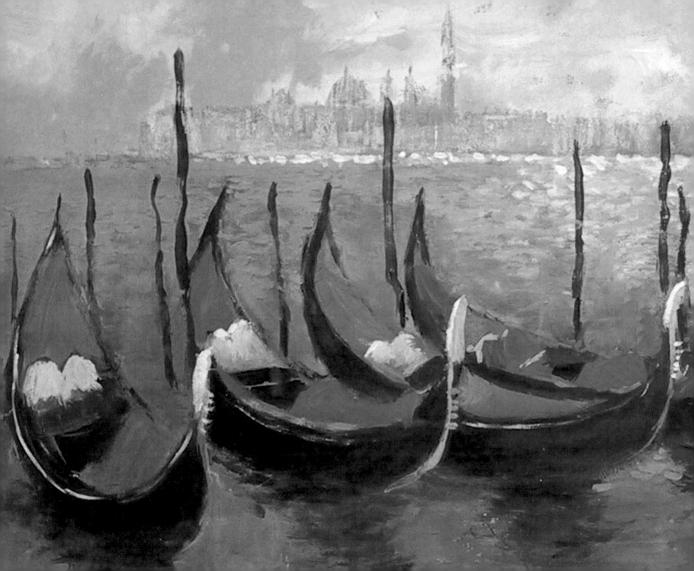

THE COMPLETE PICTURE

By this stage, you should be ready to tackle a complete painting. In this chapter, there are a few suggestions but, ultimately, as an artist, you will develop your own thoughts and ideas. After all, a huge part of the fun is gathering information, processing ideas, and seeing them to fruition.

There is a great thrill when things go according to plan, but they won't always do so. However, don't be disheartened by failures along the way—regard them as stepping stones to help you toward your goal of achieving successful paintings in just 30 minutes.

Gondolas

 11×15 in. $(28 \times 38$ cm) Here, the subtle color of the distant buildings contrasts with the dark of the gondolas to add depth to the painting.

Landscapes

The sheer scale of the great outdoors can be overwhelming for the beginner, particularly if you have only limited time in which to paint. A viewfinder is a great tool for narrowing down sections that may interest you; to make one, just cut an aperture of the appropriate shape in a piece of thin cardboard. Hold it up in front of you and look at the landscape through it to judge what might make a pleasing composition.

If there are too many details, simplify them, and remember that you don't have to paint what is there—an ugly building or some feature that doesn't suit your composition can be omitted. Every landscape you paint will help to train your visual and observational skills, which are just as important as your technical abilities, if not more so. Seeing the world through an artist's eye is a joyful experience.

► The Red Landscape

 14×14 in. (35×35 cm) The hot colors of this landscape were inspired by the red poppy fields of the summer. I used mainly tube color to paint this picture.

▲ Lavender Fields, Tuscany

10 × 10¼ in. (25 × 26 cm) The perspective of these fields really appealed to me. I used heavy body pigments for this picture, and made a few different shades of cool and warm purples to paint it.

Cornfield

 12×15 in. (30×38 cm) I liked the contrast of light and dark with the tree and the foreground against the cornfield. I used System 3D Yellow Ochre mixed with white in the foreground, with dabs of Cadmium Red to provide accents of color.

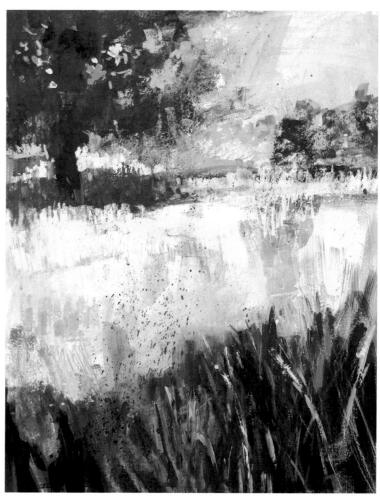

Still life

Still life is one area of painting where the artist has complete control over the design element of the work. It is a great discipline for the artist because it accustoms the eye to judging tonal values and the relationship between different shapes. Directional light from one side or backlighting makes a more dramatic and interesting composition, and the tonal values are very clear to read. A still life is also a good subject for a painting in 30 minutes if you don't have enough time to go out and about.

Still Life with Anemones

 12×14 in. (30×35 cm) I painted this still life with a combination of inks and thicker color. I used some torn pieces of tissue paper as collage to create a textural effect.

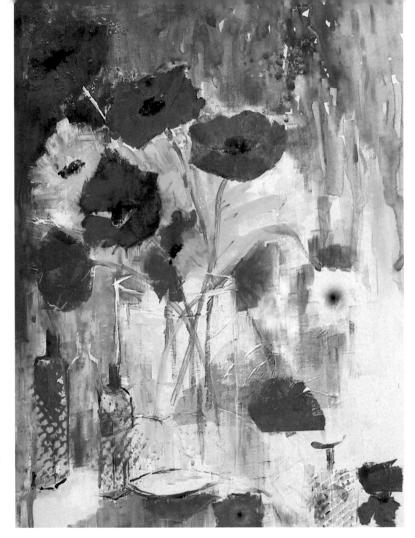

✓ Still Life with Fruit

12 × 16 in. (30 × 41 cm) First, I made an underpainting of yellow, blue, magenta, and a touch of orange. I used a spotlight to illuminate the subject from the lefthand side and added highlights to the painting accordingly.

Water

A vast area of our planet is covered in water, and in its many and varied forms it offers the artist a whole range of opportunity. Harbors and marinas are particularly interesting, with the inclusion of buildings, boats, and people.

The color of water varies a great deal, ranging from the deep blues, purples, and turquoise of tropical seas to the deep greens and muddy browns of rivers and stagnant ponds. It is highly changeable according to the season, the weather, and the time of the day, and it needs careful observation in order to paint it in a convincing way.

▶ Tranquillity

 11×11 in. $(28 \times 28$ cm) I used rich color to create the amazing skies. The late afternoon sun catching the sail of the boat makes a good contrast against the dark colors.

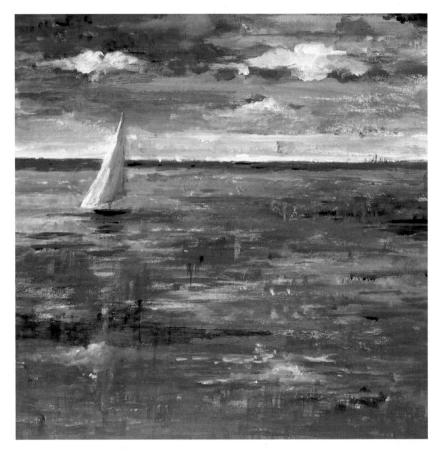

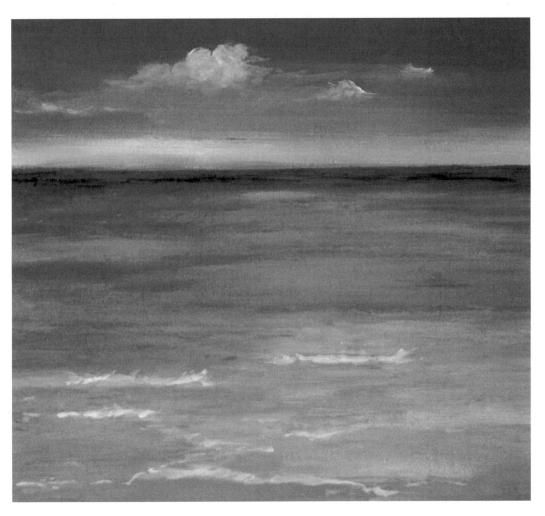

Colors of the Caribbean

 15×16 in. $(38 \times 41$ cm) Acrylic color really lends itself to depicting subjects such as this, where the gradation of color from deepest blue to turquoise is necessary.

Urban landscapes

Cityscapes and townscapes often include people as well as buildings, both of which have some challenging issues for the artist. It's best to tackle these elements individually before attempting a complicated cityscape. In your initial paintings, make the buildings more important than the people and vice versa.

All the horizontal parallel lines of the buildings will appear to converge at a single point on the horizon line, which is at your eye level. The size of your figures should be smaller as they get farther away, but in the case of adults their heads should remain at the same height.

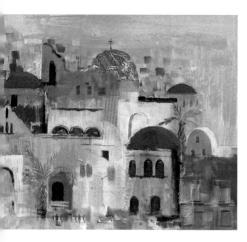

New York Buildings

4 × 8 in. (10 × 20 cm) I chose a very small section of the complicated New York skyline and treated it as simple geometric shapes using a single color. I then added shadow color in order to create dimension and suggested windows to bring the buildings to life.

Greek Island (detail)

This is a collage of some of my favorite Greek buildings. I have simplified what was a very busy harbor into shapes and forms that are typical of Greece.

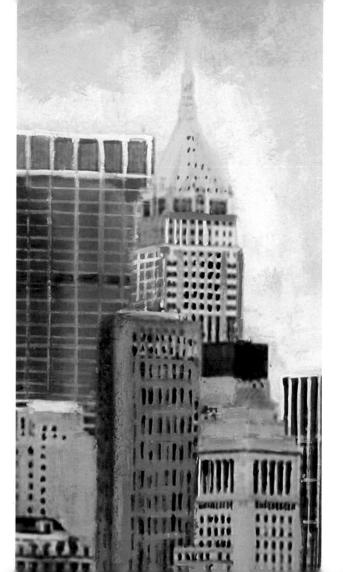

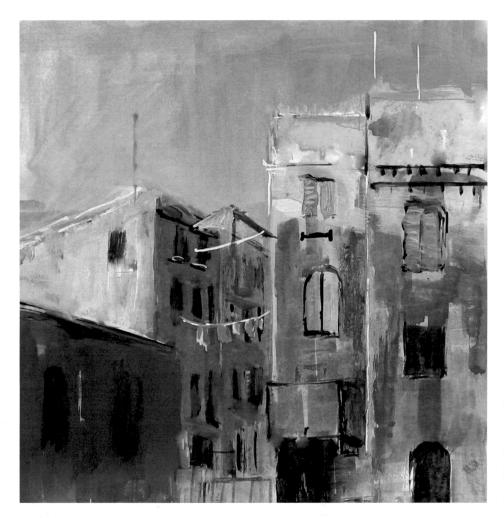

Venice

8 × 8 in. (20 × 20 cm) These Venetian buildings were comparatively simple in terms of perspective. I used a combination of transparent and opaque pigment.

Figures in the landscape

Figures add scale to a landscape and animate the picture. To make them convincing, you must get the proportions of the figures right—common mistakes, such as drooping shoulders, short arms, and large heads, can make figures appear wooden and static. Of course, you also need to make sure they are in proportion to the landscape features around them.

Eliminate unnecessary detail and suggest figures with a few broad brushstrokes to create movement and energy. In crowd scenes, pick a few key figures that interact by facing them toward each other. A painting that includes figures will convey a whole range of moods and emotions to the viewer.

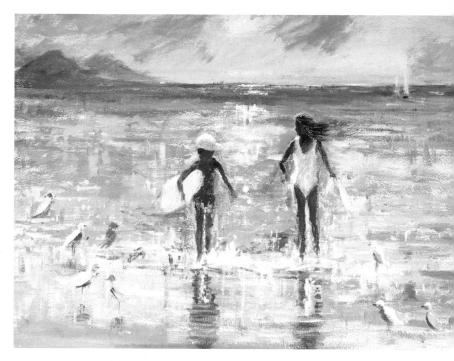

▲ Body Boarding 18 × 22 in. (45 × 56 cm) In this painting, there is a lot of movement expressed by both the figures and the seagulls. I used broken color with layers of different blues and purples in order to break up the surface of the sea. After initially laying a wash of ink, I then used thick color.

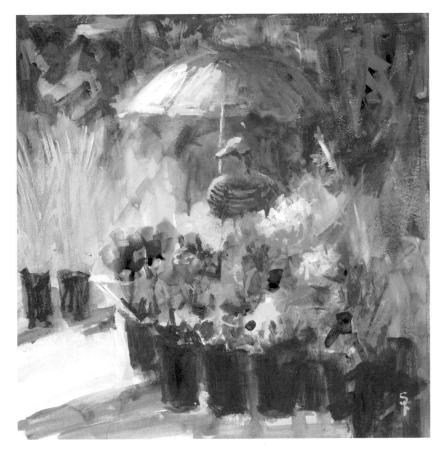

Flower Market

 11×11 in. $(28 \times 28$ cm) I liked the drama of light and dark in this picture, and blocked in the tonal values in dark purple, blue, and green. The area of flowers was suggested with dabs of color with minimal amount of detail.

QUICK OVERVIEW

□ Look through a viewfinder to scale down an area of interest in a landscape.

□ Use the effect of light and dark to add drama to your painting.

□ Simplify urban landscapes, making figures or buildings the main subject.

FURTHER INFORMATION

Here are some organizations or resources that you might find useful to help you to develop your painting.

Art Magazines American Artist 770 Broadway New York, NY 10003 tel: (646) 654-5506

Artists & Illustrators 26-30 Old Church Street London SW3 5BY England www.aimag.co.uk

The Artist's Magazine 4700 E. Galbraith Road Cincinnati, OH 45236 tel: (513) 531-2690 www.artistmagazine.com

International Artist P.O. Box 4316 Braintree, Essex CM7 4QZ England www.artinthemaking.com *Leisure Painter* Caxton House 63/65 High Street Tenterden, Kent TN30 6BD England tel: 01580 763315 www.leisurepainter.co.uk

Art Materials Blick Art Materials tel: (800) 723-2787 www.dickblick.com

Cheap Joe's Art Stuff tel: (800) 227-2788 www.cheapjoes.com

Daler-Rowney, USA 2 Corporate Drive Cranbury, NJ 08512 tel: (609) 655-5252 www.daler-rowney.com

Daniel Smith tel: (800) 426-7923 www.danielsmith.com *Jerry's Artarama* tel: (800) 827-8427 www.jerrysartarama.com

Nova Color Artists Acrylic Paint www.novacolorpaint.com

Pearl Art and Craft Supply tel: (800) 451-7327 www.pearlpaint.com

Savoir-Faire 40 Leveroni Court Novato, CA 94949 tel: (415) 884-8090 www.savoirfaire.com

Utrecht 6 Corporate Drive Cranbury, NJ 08512 tel: (800) 223-9132 www.utrecht.com Art Societies National Acrylic Painters Association 134 Rake Lane Wallasey Wirral, Merseyside CH45 1JW England www.napauk.org

Internet Resources Art Museum Network The official website of the world's leading art museums. www.amn.org

Painters Online Interactive art club run by The Artist's Publishing Company www.painters-online.com

Soraya French

The author's website, with details of her exhibitions and workshops, and a gallery of her paintings. www.sorayafrench.com

WWW Virtual Library Extensive information on museums and galleries worldwide. http://vlmp.museophile.com/ Additional Reading Crawshaw, Alwyn, Alwyn Crawshaw's Ultimate Painting Course, Collins, 2006

Harrison, Terry, Brush with Acrylics: Painting the Easy Way, Search Press, 2004

Reyner, Nancy, Acrylic Revolution: New Tricks & Techniques for Working With the World's Most Versatile Medium, North Light Books, 2007

Sheaks, Barclay, *The Acrylics Book: Materials and Techniques for Today's Artist,* Watson-Guptill, 2000.

Tauchid, Rhemi, *The New Acrylics*, Watson-Guptill, 2005

INDEX

Page numbers in **bold** refer to captions.

animals 52, 68, **68**, 69

basic palette 18-19 birds 68, **69** blending 44-45 bristol board 15, **15**, 22, 42 broken color 37, 45, **92** brushes 8, 14, 22, 37, 42, 62, 69, 80 buildings **9**, **55**, 72-73, 90-91

collage **9**, 54-5, **86**, **90** colors 12, 16-29, **19**, 37, **37** warm and cool 21, 22-23, 44, 76, **85** composition 74-81

diluting 8, 13, 31, 32, 68, **70** dry-brush technique **69**

equipment 10-15

figures 70-71, 92-93 flowers and foliage **8**, 18, **33**, **39**, **40**, **41**, **46**, **47**, **53**, 60-61, 79 gesso 15, 49 glazes and glazing 13, 21, 40, **40**, 44, 46, **63**, **73** gray scale 24, **24**, 26, 28

half-hour demos transparent and opaque colors 42-43 underpainting 80-81 using color temperature 22-23 heavy body colors **9**, 12, 36, 38, 42, 46, 51, **63, 85** highlights **47, 49, 68, 87**

impasto and impasto gel 36, 46 inks 13, 14, 32, **32**, **33**, 40, **41**, 42, 68

landscapes 21, 22-23, **42**, **43**, 53, 62-63, 76, **76**, **77**, 84-85, 92-93

mediums and additives 13, 45 monochrome 26-27, 28

neutral tones **17**, 18, 20, **20**

oil and oil pastels 49, 56, **59**, **61** opaque techniques 14, 36-37, 46, 69, **69**, **70**, **91** painting knife 8, **8**, 15, 36, 38-39, **38**, 52, 53 palettes 14, **14** paper 15, **15**, 32, 42 pastels 49, **49**, 56, **59**, **61** perspective 22, 72, 76, **85**, **91** projects exploring different textures 56-57 tonal values 28-29 watercolor and opaque style 46-47

quick studies 58-73

roller 48, **48** rule of thirds 76, **76**

scraping **8**, **41**, 48, **48** scratching into paint 38, **39**, **52** scumbling **43**, 45, **45**, 46 shadows **23**, **40**, 46, **47** skies 18, **21**, **46**, **88** soft body colors 12, 32 splattering **23**, **51**, **56** still lifes **25**, **27**, 28, **28**, **29**, **59**, 66-67, 76, **77**, **80**, **81**, 86-87 super heavy body colors 12, **36**, 38, 51, 52 supports 15, **15** techniques 30-49 texture paste **51**, 53, 56 textures **9**, 12, **36**, 38, 50-57, 68, **77**, **86** thumbnail sketches 78 tints 18, 20, **20** tissue paper **51**, 54, **55**, 56, **56**, **57**, **86** tonal values 24-25, 26-27, 28-29, 40, 66, 76, 78, **78**, 86, **93** transparent and opaque colors combined **11**, 40-41, 42-43, **69**, **91** trees **7**, **22**, **23**, **38**, 62, **62**

underpainting 79, 80-81, **87** urban landscapes 90-91

washes 8, **33**, 34, **35**, 42–43, 46 water and boats **34**, **35**, **55**, 64–65, **83**, 88–89 watercolor and opaque paint 46–47, **66** watercolor techniques 13, 32–35, 46–47, **67** wax resist **56** wet-in-wet 32–33, 34, 46, **61** wet-on-dry 34–35, 46, **61**, **69**